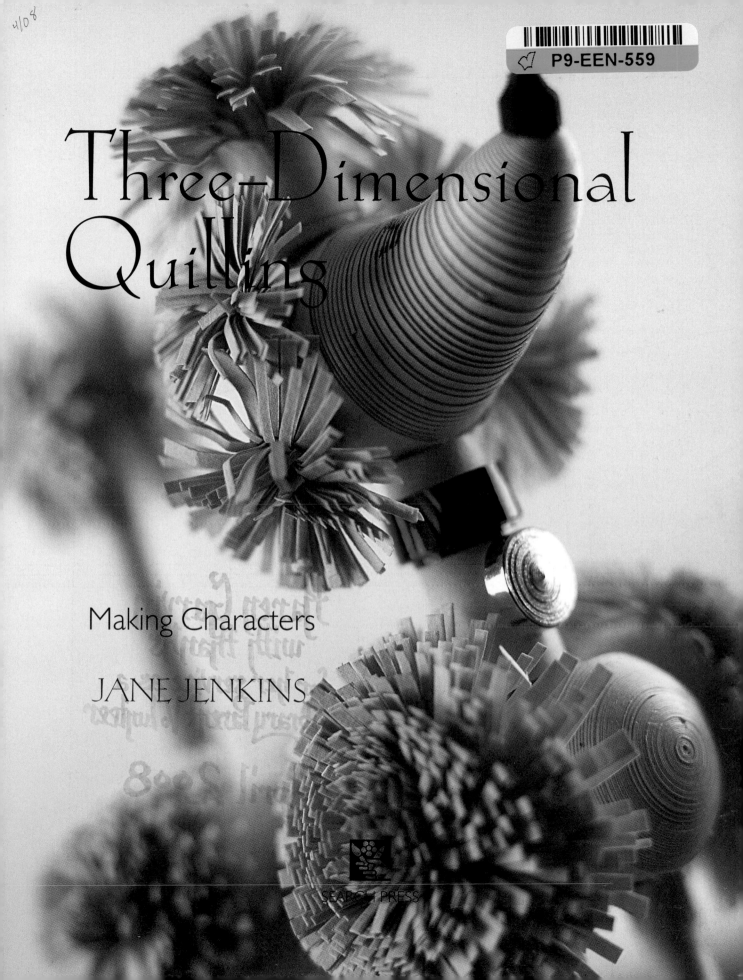

Three-Dimensional Quilling

Making Characters

JANE JENKINS

4/08

P9-EEN-559

SEARCH PRESS

First published in Great Britain 2007

Search Press Limited
Wellwood, North Farm Road,
Tunbridge Wells, Kent TN2 3DR

Text copyright © Jane Jenkins 2007

Photographs by Roddy Paine Photographic Studios

Photographs and design copyright © Search Press Ltd, 2007

All rights reserved. No part of this book, text, photographs
or illustrations may be reproduced or transmitted in any
form or by any means by print, photoprint, microfilm,
microfiche, photocopier, internet or in any way known or
as yet unknown, or stored in a retrieval system, without
written permission obtained beforehand from
Search Press.

ISBN 10: 1-84448-204-9

ISBN 13: 978-1-84448-204-7

The Publishers and author can accept no responsibility for
any consequences arising from the information, advice or
instructions given in this publication.

Readers are permitted to reproduce any of the items in this
book for their personal use, or for the purposes of selling
for charity, free of charge and without the prior permission
of the Publishers. Any use of the items for commercial
purposes is not permitted without the prior permission of
the Publishers.

Suppliers

If you have difficulty in obtaining any of the materials and
equipment mentioned in this book, then please visit the
Search Press website for details of suppliers:
www.searchpress.com

Publisher's note

All the step-by-step photographs in this book feature
the author, Jane Jenkins, demonstrating three-
dimensional quilling. No models have been used.

Conversion table

Most of the measurements in this book are given in
both metric (millimetres) and imperial (inches) units.
However, it would be too cumbersome to convert all
the widths of the paper strips used, so they are
recorded here:

2mm	$1/12$in	10mm	$3/8$in
3mm	$1/8$in	15mm	$5/8$in
5mm	$3/16$in	3.5cm	$1^3/8$in
8mm	$5/16$	4cm	$1^5/8$in

Acknowledgements

The quillers who have influenced me over the
past twenty-five years are just too numerous
to mention but I'd like to take this opportunity
to name a few whose lovely work has had a
permanent effect on my quilling thinking.

First, of course, Paul, who is one of the few who
prove that quilling is not solely a female pursuit.

Cate, for her delicate quilling and Jo for her
arty stuff.

Elizabeth Ribet, for her pioneering early work.

Barbara Fitch for her inspirational straw-work.

Manami Omata, who convinced me that little
quilled characters should be the subject of a book.

Margaret Haigh, Brenda Rhodes, Diane Crane,
Jean Wilkinson and Mary Cooze for their
innovations and unique quilling over many years.

Shiro and Noriko Ono and Mrs Kazuko Inaba,
Licia Politis and Claire Choi, for their more recent
fabulous work.

Most of all, Audrey Matthews, because her super
quilled characters have always made me laugh.

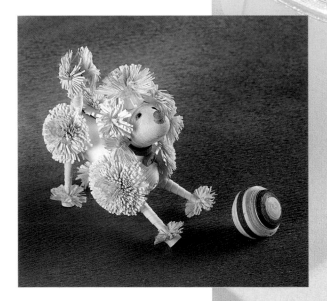

Front cover

*To give an idea of scale, the main fairy shown on the front
cover is 7.6cm (3in) high.*

745.54
JEN
2007

Contents

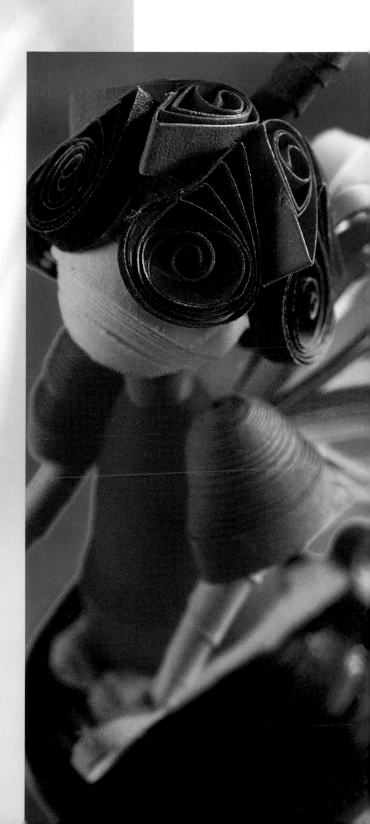

Introduction

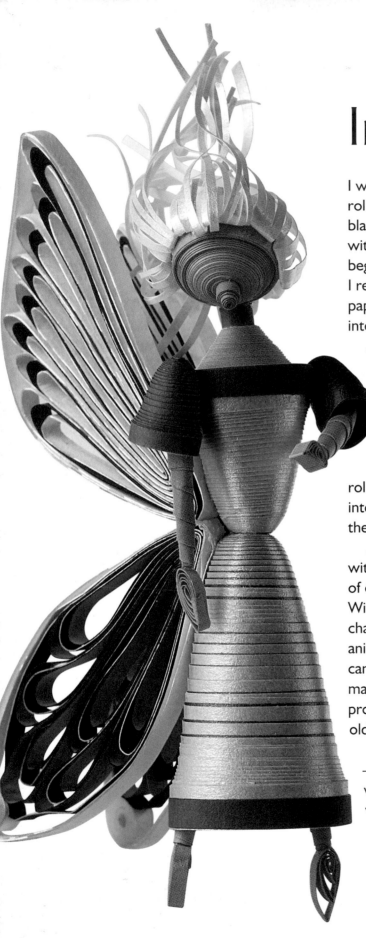

I wonder how many quillers remember that rolls of wallpaper used to come with an extra blank strip at the edges, which had to be cut off with a pair of scissors before the pasting could begin. None of you is old enough, I'm sure! But I remember playing with these cut-off coils of paper, rolling them tightly and pushing them into shapes.

A couple of decades later, I remembered that fun when teaching history to eight-year-olds. We were 'doing' the Vikings and needed horns for our papier-mâché helmets. I, like everyone else at the time, was unaware that there is little historical evidence for horned helmets so we happily rolled up wide strips of paper and pushed them into cone shapes which made great horns, to the delight of the children.

Another decade later, I began making models with quilling and realised, once again, the value of cone coils, cup coils, solid coils and ring coils. With them, we can create fabulous quilled characters, simple and fantastic, human and animal, serious and comical. Cup and cone coils can be found often in antique quilling but not for making characters so we modern quillers can proudly say we are breaking new ground, using old techniques and making history.

Three-dimensional quilling is such a joy – everyone should try it, so I hope this book will provide help and inspiration for those who need it.

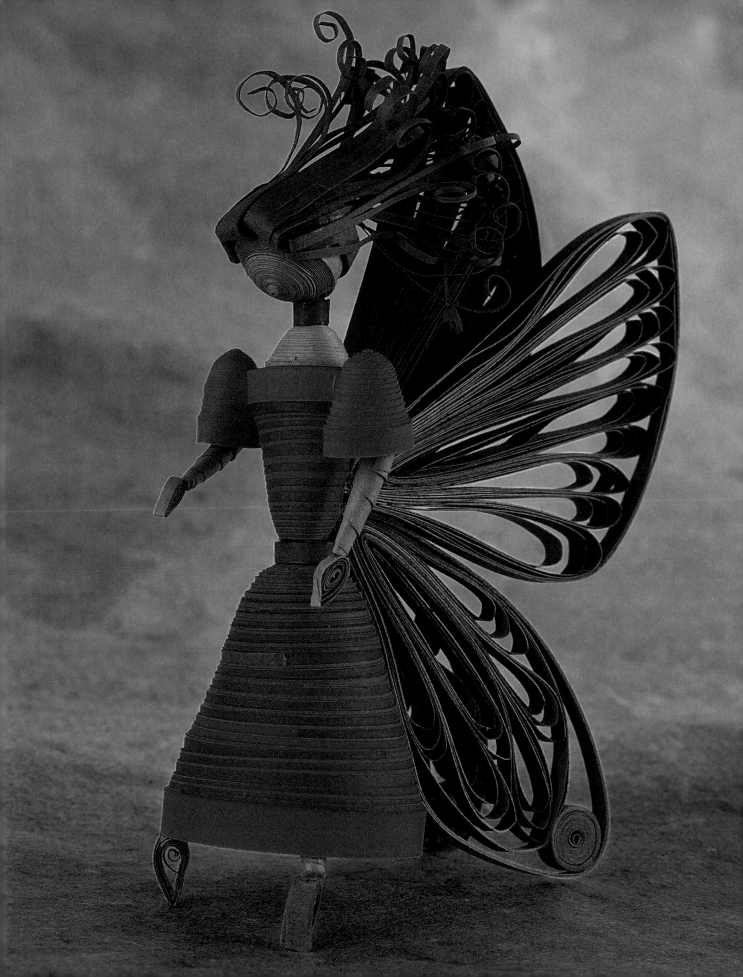

Materials

Quilling strips

Quilling strips come in a large variety of colours and types. The standard length is 45cm (18in). The standard width is 3mm but three-dimensional quilled characters often make use of wider strips – between 5mm and 15mm is normal.

The perfect weight paper for quilling strips is around 100gsm. However, paper manufacturers sometimes make lovely colours, but in the wrong weight for quilling, so that they feel softer or stiffer than is usual. This is not much of a problem, mostly, but the size of tight coils – the coils we use most in model making – can be considerably affected by these differences. Strip lengths or numbers, therefore, might not always be given because it is more helpful for you to know the final diameter required.

Antique quilling often made use of strips with a gilt edge. As usual, modern quillers have taken this old idea, developed and modernised it and make use of strips with not only metallic gold foil but also silver, holofoil, pearlised and more – wonderful for fairies' wings. Some strips also are made from super-shiny 'mirror' paper, not so easy to work with but the results are well worth it (see the Angel project on page 40).

Paper sheets

Sometimes it is more convenient to use strips that you have cut by hand from sheets of paper. The angel's hands require small rectangles of coloured paper and the Poodle project (page 24) uses tubes made from wider strips. Take care that the paper you cut is the same white as the pre-cut quilling strips.

Glue

The best glue for most quilling is PVA. Good quality PVA is pure white – not transparent in any way until it is allowed to dry. It also has a thick, creamy consistency and is suitably tacky. Use as little as possible; a good quiller produces work with absolutely no glue marks. You will also need extra strong PVA glue for less absorbent papers, like the gold mirror strips used for the Angel project.

Other equipment

Cocktail sticks These can be used not only for applying glue, but also as a tiny dowel to form a long, thin cone.

Kebab stick This is used as a dowel when something slightly wider than a cocktail stick is required.

Wooden dowels I have these made specially in my favourite sizes but you can get sets of them from suppliers.

Quilling tools Personally, I prefer not to use a tool for normal rolling because there is a danger of producing coils with a bent-back middle. However, there are some occasions when this would not show and a tool can be very helpful.

Tweezers I find these invaluable and have different ones for different jobs but the projects in this book simply need one easy-to-hold, fine or extra-fine pair.

Scissors If you are cutting your own wide strips for pom-poms, tubes etc., a long pair of scissors is useful. Then you will need a very fine, straight pair for fringing and general fine work.

Onion holders and masking tape For spreuer-work when you make the wings for the Angel project on page 40.

Ruler To measure strip widths and tight coil diameters.

Fine fibre-tip black pen For marking in eyes.

Dowels of various sizes and shapes To help make ring coils.

Clockwise from top left: masking tape, kebab stick and cocktail sticks, wooden dowels, quilling tools, fine and extra-fine tweezers, long and fine scissors, onion holders, a ruler, pencil, fine fibre-tip black pen and various dowels.

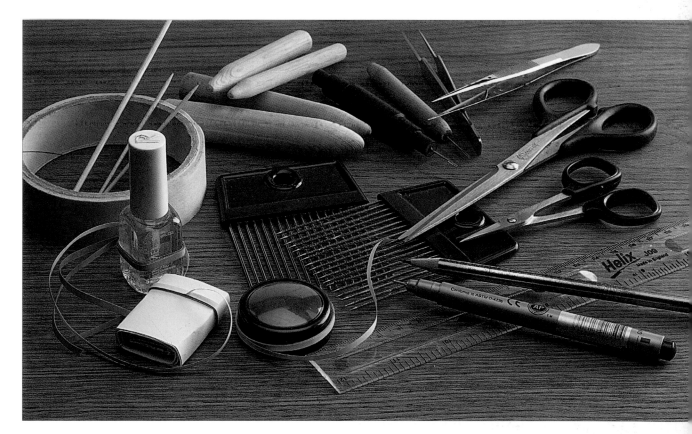

Basic techniques

Closed loose coil

Closed loose coils may be formed into a variety of shapes. This is how I make the basic coil using a half-length 3mm strip.

 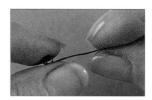 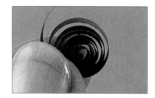

1 Scratch the tip of the strip with your fingernail against your thumb to curl it.

2 Bend over the very tip of the strip. It can help to have slightly damp fingertips.

3 Rub your finger along your thumb and the strip will begin to roll between them.

4 Continue rolling to the end of the strip, then release the coil. It will spring open.

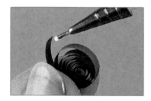 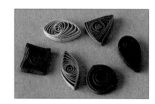

5 Glue down the end of the coil where it naturally lies. Do not pull it into place.

Closed loose coils can be squeezed into many different shapes, as shown.

End-to-end rolling

This is achieved by gluing two strips together end-to-end before rolling, to create a coil with a different colour towards its centre.

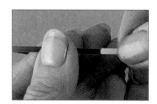

Solid coil

This is simply a coil rolled as tightly as possible and glued down. A perfect solid coil has a smooth, even surface and no hole at its centre. A fine, smooth coating of PVA glue can help. Instructions often do not give strip length or numbers because you simply roll, adding more strips as necessary, until the coil reaches the given diameter.

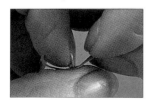 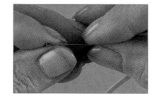 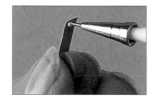 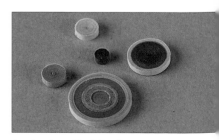

1 Scratch the end of the strip a great deal, until it is quite soft.

2 Roll the end, aiming to leave no hole at the centre.

3 Roll the strip tightly. Do not release it. Glue the end.

A selection of solid coils.

Cup coil

These are made from solid coils. Some quillings need quite deep cup coils and two glued together can make a 'ball'.

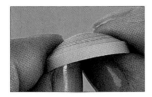

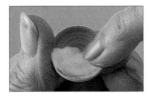

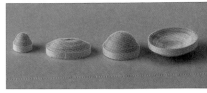

1 Press the solid coil into a dome shape.

2 To prevent the coil from collapsing, use your finger to coat the surface of the cup coil with glue.

To make an oval solid coil, fold the beginning of the strip instead of rolling. An oval cup coil can be made by pushing the oval solid coil into a dome shape.

A selection of cup coils. With oval cup coils, you may have to push glue into the centre as well as across the surface, and squeeze as it dries, to ensure a good, secure coil.

Cone coil

Cone coils are also made from solid coils but usually with wider strips. Cone coils may be tall and thin or big and wide. The trick is to achieve this size and shape without the coil collapsing! I call my favourite method the 'Marycooze method', named after the lady who invented it.

Marycooze method

Dowel method

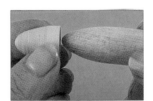

Potter's method

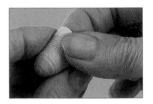

1 Use three 5mm wide strips to make a solid coil. Push it into a cup coil to get it started.

2 Hold the coil between fingers and thumbs and press it with alternate hands. The cone grows like magic!

You can push the cone into shape using a wooden dowel, which can be bought in sets or made specially.

Turn the cone on your finger and shape it by pressing your finger and thumb together as you turn.

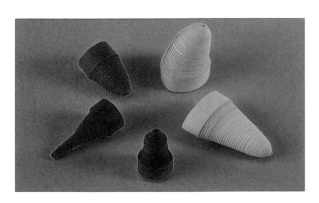

A selection of cone coils. There is nothing worse for a quiller than achieving a super, tall, smooth cup or cone coil, only to have it collapse or break, so all of them must be coated with a fine layer of PVA glue. I usually use my fingers for this, rather than a brush, because that way I can sense any weaknesses. Coat either the inside or the outside, or both surfaces of your coil. The outside is more messy, but will give good protection against marks and dust.

You can push a cone coil into a curved shape or press into into an oval while the inside coating of PVA is still wet.

Ring coils and tubes

These can be made around dowels of various diameters from a cocktail stick to a mixing bowl. You can even make your own dowels to the required size, using card. I prefer to start coils on a dowel and then slide them off and continue by hand. A ring coil made from a very wide strip might more accurately be called a 'tube'.

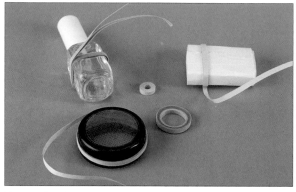

Various dowels used to create ring coils. Coat the face of ring coils with glue as with cup and cone coils.

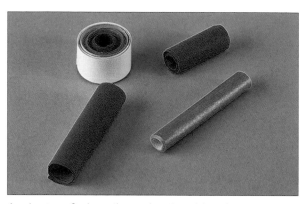

A selection of tube coils, made using wide strips.

Wheatears

This is how to make the basic wheatear. It can then be formed into different shapes.

1 Make a loop at the end of a strip and glue it in place.

2 Bring the strip around the first loop to make a slightly larger loop.

3 Hold the loop sideways while you put a tiny dot of glue at the pointed end. Bring the loop round again and repeat.

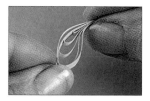

4 Continue to loop until the wheatear is as big as you want it to be, adding more strip if necessary. Finally, glue down the end.

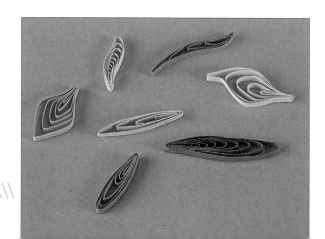

A selection of wheatear coils.

Pom-poms

These are made by rolling a fringed length of paper, usually a wider than average strip. Fringing is quicker if the paper is folded first.

1 Take a half-length 10mm wide strip and fold it in half twice. Fringe it up to 3mm ($^1/_8$in) from the edge.

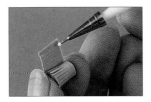

2 Unfold the fringed strip, roll it up and glue down the end.

3 Spread the fringes.

A selection of pom-poms. Pom-poms can be made in different sizes by altering the lengths and widths of strips.

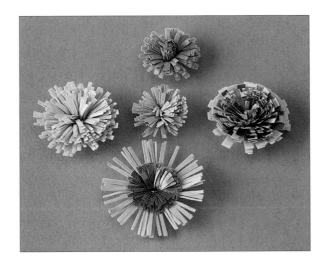

Tendrils

These are useful for characters' arms and legs.

1 Roll a 3mm wide strip 'helter-skelter-like' along a cocktail stick or other dowel.

2 Take the tendril off the dowel and then stretch and twist it to tighten it.

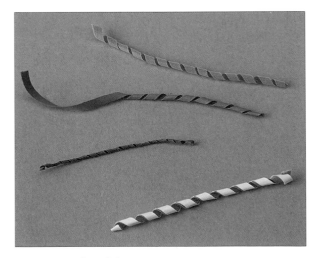

A selection of tendrils.

Finger Puppet

The very first quilled models I made were finger puppets; they are very simple, small but not too fiddly and, of course, there is plenty of scope for variation. Children love them too, both to make and to play with, since they are really quite strong, especially if coils are all coated with PVA glue. Once you have got the idea, the possibilities for making more to join the gang are endless but if you should get short of ideas, just ask a child to come up with more.

You will need

- Four 5mm white strips
- One 5mm bright pink strip
- Four 5mm strips in peach/flesh colour
- One 5mm yellow strip
- One 5mm pink strip
- One 5mm black strip
- Fine black fibre-tip pen
- Kebab stick

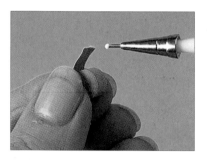

1 To make the head, roll a peach/flesh-coloured strip as tightly as possible with little or no hole at the centre. Glue down the end.

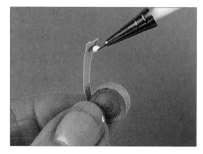

2 Add another strip and continue to roll. Glue down the end to make a solid coil.

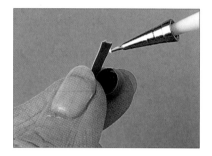

3 To make the mouth, glue an eighth of a pink strip to an eighth of a black strip and roll them up, beginning at the black end. Release the coil completely and glue down the end.

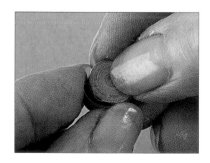

4 Push this closed loose coil around the curve of the solid coil and glue it in place.

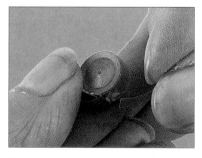

5 Add a third peach/flesh-coloured strip and roll as tightly as possible. Add a fourth strip and roll tightly.

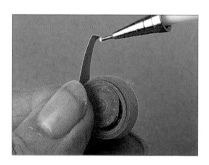

6 Glue down the end of the fourth strip to complete the face.

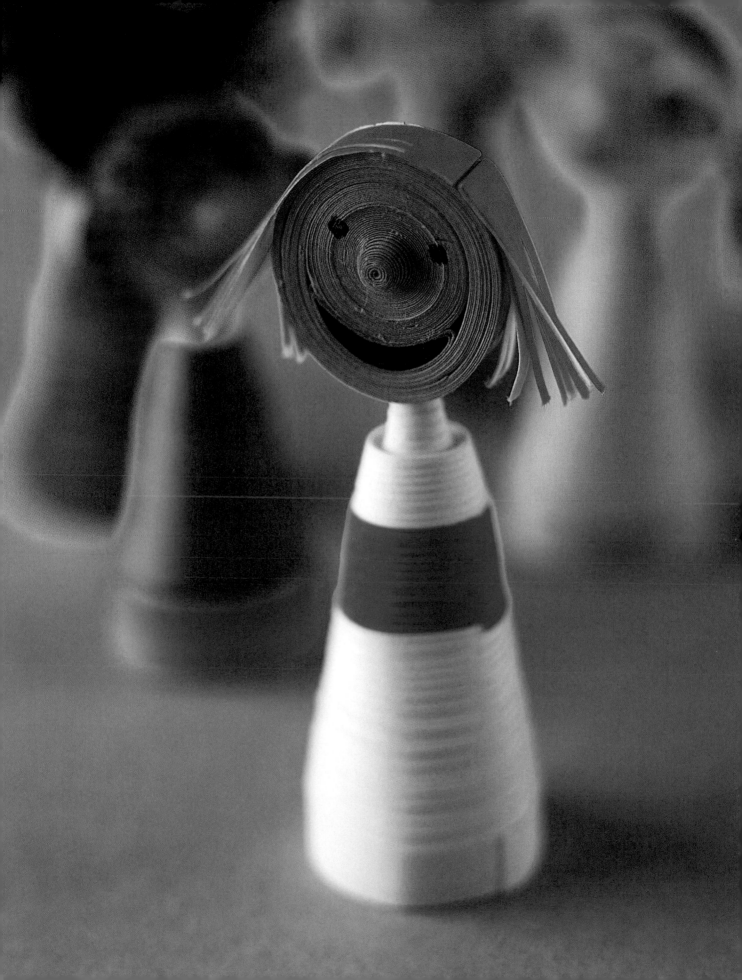

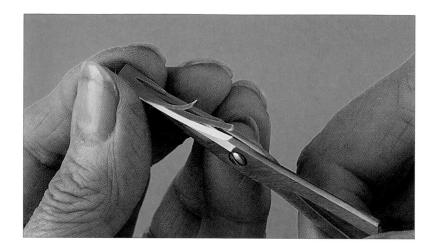

7 To make the hair, fold a 6cm (2³/₈in) long 5mm wide yellow strip in half and snip as finely as possible up to an eighth of the fold.

8 Glue to the head, off-centre, to give the finger puppet a side parting. Repeat with a 4cm (1⁵/₈in) long strip at the other side and then give her a haircut if necessary.

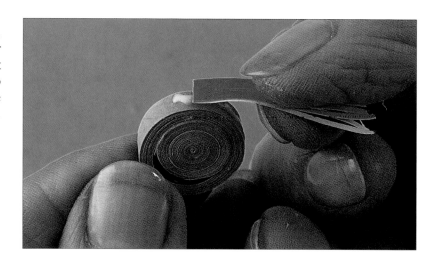

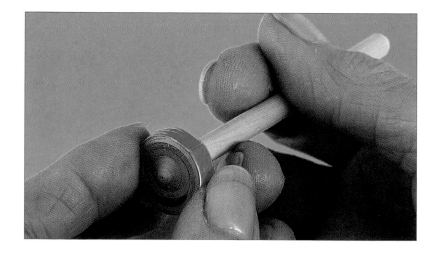

9 Push a dowel into the centre back of the head to make a nose appear at the front. Coat the back of the head with glue so that it remains firm.

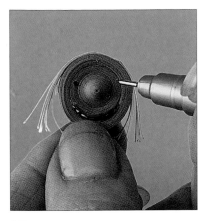

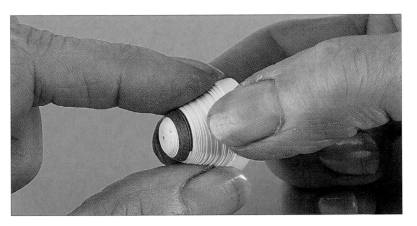

10 Mark the eyes with a fine black fibre-tip pen.

11 To make the body, roll up a white strip as tightly as possible. Glue it down, add first a bright pink strip and then three more white strips to make a solid coil. Shape into a cone coil, around 3cm (1¼in) tall.

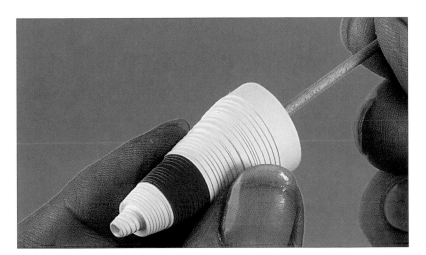

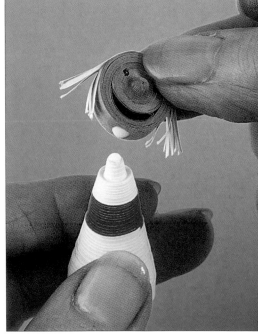

12 Use the flat end of a kebab stick to create a neck by pushing up the centre of the coil and then coat the whole body with PVA glue.

13 To glue the head to the body, put a blob of glue on the neck and another on the head and wait for them to go tacky before sticking them to each other.

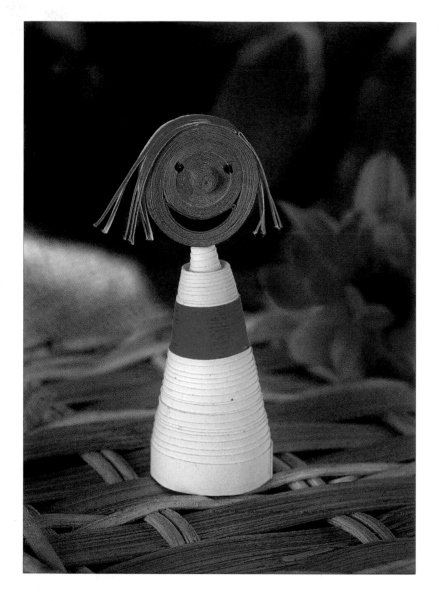

The finished Finger Puppet project.

Opposite

The finger puppet characters in this happy scene can be made using the items shown at the bottom left of this page.

The earrings are ring coils formed around a pencil or smaller dowel. Use a quarter-length strip, preferably 2mm wide, but 3mm will work.

The spectacles are ring coils formed around a pencil or smaller dowel. Use a quarter-length 2mm wide strip if you can. Then make a thick strip with four 1cm (³/₈in) lengths glued together. Bend this and link the rings together.

The ears and mouth are closed loose coils made from eighths, or even sixteenths, of a 2mm or 3mm wide strip. Form them into ear or mouth shapes.

The long hair is made by snipping 5mm wide strips (see step 7). Curve them a little and glue to the head, backwards. Give the puppet a haircut if necessary. For the fringes, snip very short 5mm wide strips. Curve a little and glue to the head, forwards. Trim the fringe if necessary. Hair can be made curly by rolling the ends a little before gluing to the head.

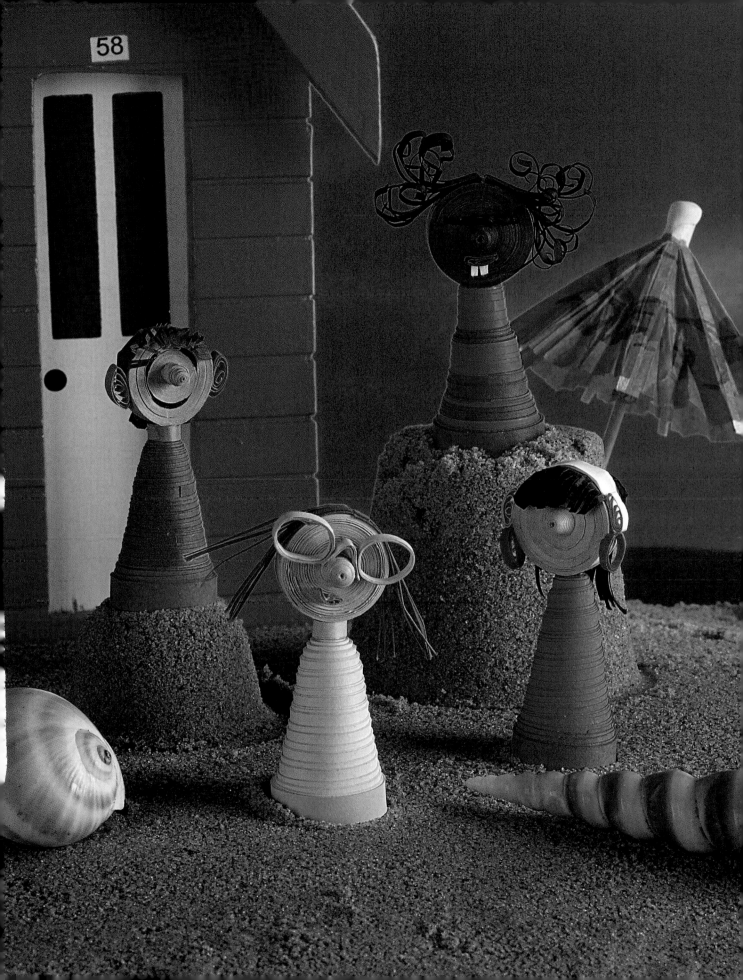

Long-legged Frog

I got the idea for these long-legged characters when I saw some wooden ones with string arms and legs. They are happiest sitting around looking cute but you could also make them into simple puppets by fixing strong thread or shearing elastic to the head. Arms and legs will lollop around to the great amusement of all.

You will need

- Approximately twelve 10mm wide dark green strips
- Approximately twenty-five 3mm wide dark green strips
- Fifteen 3mm wide light green strips
- Three 3mm wide black strips
- One 3mm wide white strip
- Cocktail stick
- PVA glue
- Fine scissors
- 15mm (⁵⁄₈in) dowel

1 To make the body, use about eight 10mm wide dark green strips to make a cone coil approximately 4.5cm (1¾in) tall.

2 To make the head, use 3mm wide dark green strips to make a solid coil. Continue adding strips, one at a time, until the coil is 2.25cm (⁷⁄₈in) in diameter. Add an extra light green strip to define the mouth.

3 Press this solid coil into a cup coil and coat the inside with glue. Before the glue is dry, press the coil into an oval shape.

4 You need to make two of these coils. Glue them to each other so that the mouth is a little open. Put a blob of glue on the outside rim of the top coil and on the inside rim of the bottom coil and wait for the glue to go tacky before pressing the coils together.

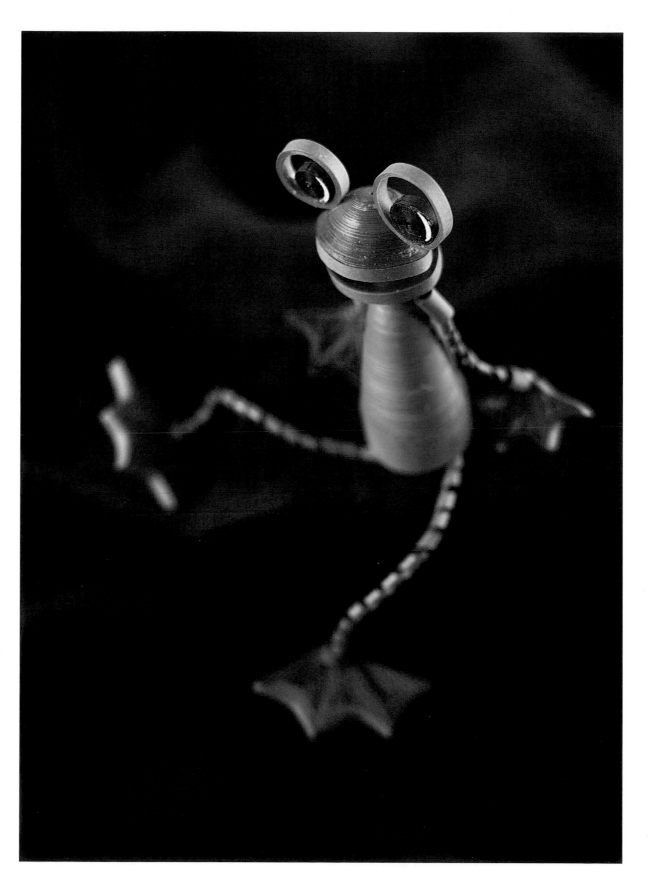

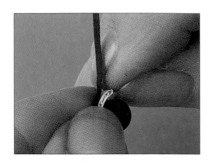

5 To make the eyes, wrap a 3mm wide, full-length, light green strip around a pencil to make a ring coil. Glue down the end. Make another, larger ring about 2cm (¾in) in diameter.

6 Roll a 3mm wide, 2cm (¾in) long, white strip. Release it and press it flat.

7 Roll a black 3mm wide strip into a solid coil. Do not roll the whole black strip. When about 8cm (3¼in) is left, incorporate the tiny white coil and continue rolling the black. Glue down the end. This will make an eye with that all-important highlight.

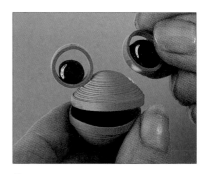

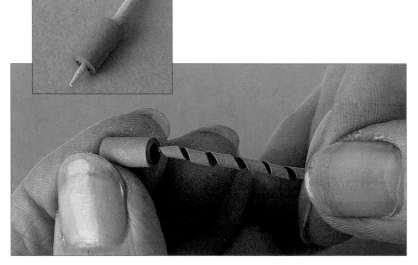

8 Make a larger eye with a highlight, this time using two black strips. Glue each black eye inside a green ring coil and glue them both to the frog's head.

9 To make the arms and legs, use 3mm wide strips, quarter length for the arms and a third length for the legs. Make them into tendrils and push each end into a ring coil (tube) made from a quarter of a 10mm wide strip, rolled around a cocktail stick.

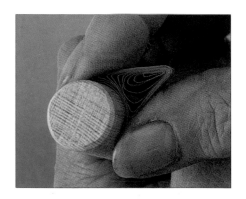

10 To make the hands and feet, use 3mm wide strips to make twelve wheatear coils. Each of the three wheatears needed for a foot will use up as much of a full-length strip as possible. Cut off any excess strip. Each wheatear for the hands uses about a half-length strip. Shape each wheatear using a 15mm (⅝in) diameter dowel as shown.

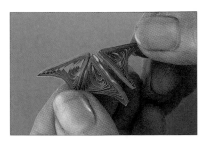 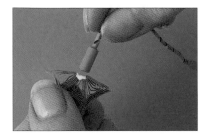 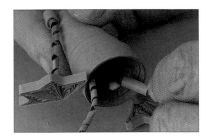

11 Glue three shaped wheatears to each other.

12 Glue the hands to the arms and the feet to the legs.

13 Glue the arms to the shoulders. Glue the legs to the inside of the body as shown.

The finished Long-legged Frog project.

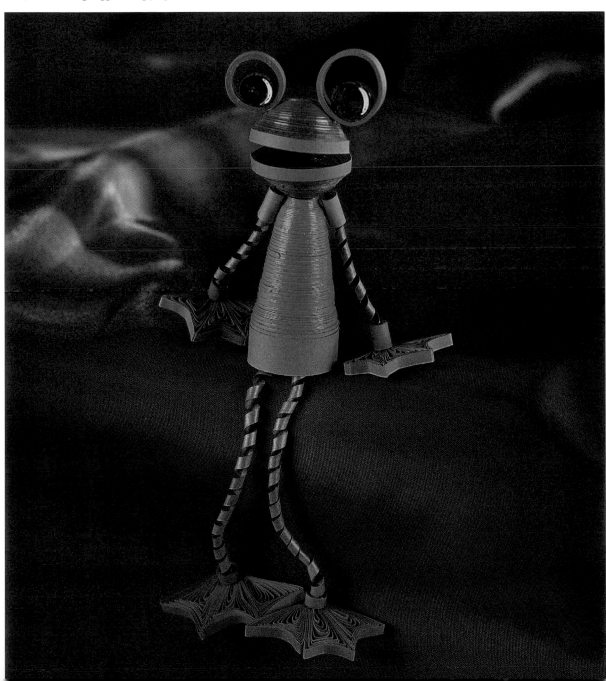

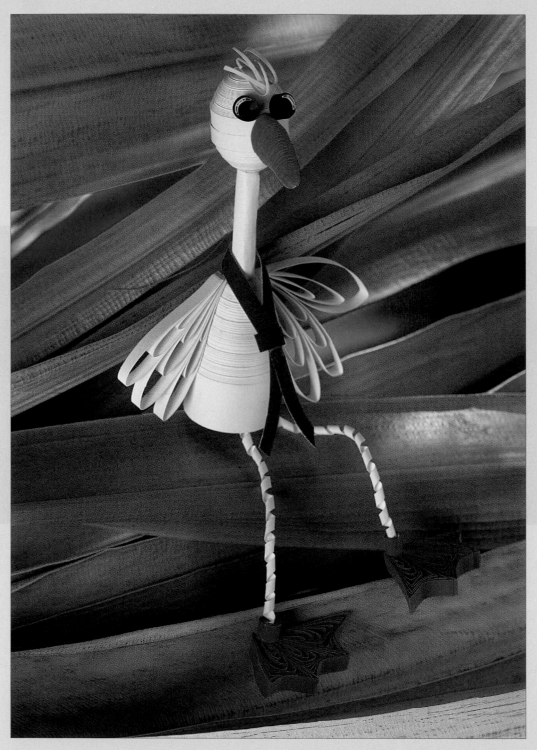

This relaxed-looking bird is the same as the frog with the following exceptions: the head is a 'ball' made from two cup coils, each using six 5mm wide strips. The beak is a curved cone coil made from one 5mm wide strip. The neck is a ring coil (tube) made from a 4cm wide, 6cm long strip, rolled around a kebab stick. Eyes with highlights are made from half-length black strips. The head tuft is an eighth of a 5mm wide strip, cut as finely as possible and curved.
The wing is made from three wheatears.

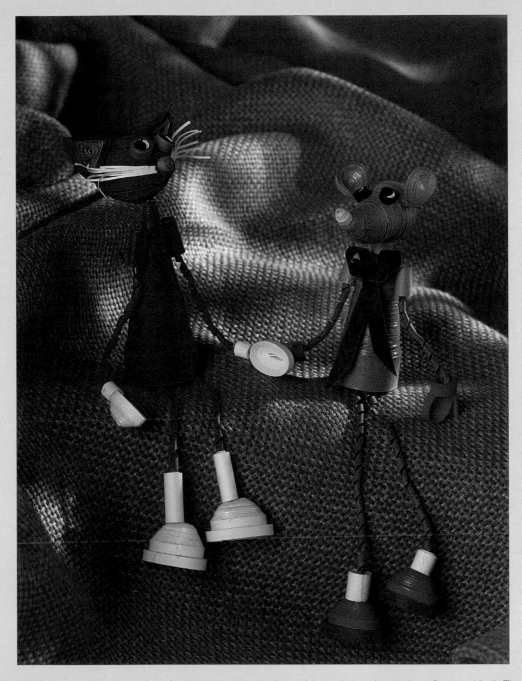

The cat's head has the same coils as the frog but they are glued together and closed to make a flattened ball. The hand is an oval cup coil made from a full-length strip. Shoes are oval solid coils made from two and a half 3mm wide strips, glued to an oval cup coil of two 3mm wide strips. The ears are closed loose coils, half a peach/flesh-coloured strip glued to a half orange strip, 'end-to-end' rolled; roll from the peach/flesh end and press into a triangle shape. The eyes are solid coils made using a quarter-length black strip with an eighth green strip added.

The mouse's body, arms and legs are as for the frog. The back of the head is a cup coil made with six 3mm wide strips. The front of the head is a curved cone coil of six 5mm wide strips. Push to 3cm (1¼in) in length and then curve slightly. The nose is a cup coil made from a quarter-length, 3mm wide strip. Ears are a cup coil of two 3mm wide strips, shaped. The eyes are as for the frog, using half-length black strips. The neck is a quarter-length ring coil using a 10mm wide strip. The hands are oval cup coils, each made from two full-length strips. Their thumbs are cone coils made from a quarter-length, 5mm wide strip, using a cocktail stick as a dowel. The shoes are as for the cat.

Poodle

A very small version of this poodle appeared in my book, *Quilling Techniques and Inspiration*. I have had lots of requests for instructions so here they are, for a slightly bigger, less fiddly version. You can always adjust the sizes of the strips to make smaller ones, if you like. This poodle requires a few exceptionally wide strips. You could cut these yourself from sheets of plain paper, which can be bought from a good supplier.

You will need

White strips:
approximately three
3.5cm wide;
one 15mm wide;
approximately twelve
10mm wide;
two 8mm wide,
three 5mm wide and
approximately twelve
3mm wide

One 3mm wide
scarlet strip

One 3mm wide
pink strip

One 2mm wide deep
yellow strip

Fine black fibre-tip pen

Cocktail stick

PVA glue

Fine scissors

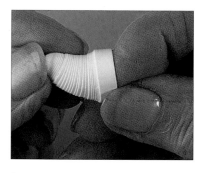

1 To make the head, first take three 5mm wide strips to make a curved cone coil which should be 2.5cm (1in) long.

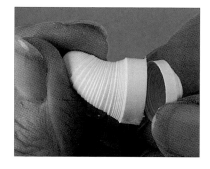

2 Then use three 3mm wide strips to make a cup coil. Glue it to the curved cone coil.

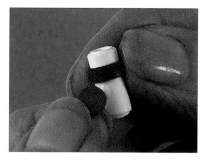

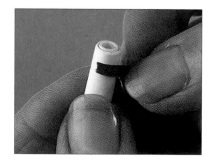

3 To make the nose, use a quarter of a 3mm wide pink strip to make a tiny cup coil. Glue it in position.

4 To make the neck, roll a 15mm wide strip until it has a diameter of 7mm (¼in). Tear off any excess strip and glue down the end. To make the collar, wrap half a 3mm wide scarlet strip around the neck, 2mm (¹⁄₁₆in) from the top.

5 To make the medallion, use half a 2mm wide deep yellow strip to make a solid coil. Glue this to the neck, just below the collar.

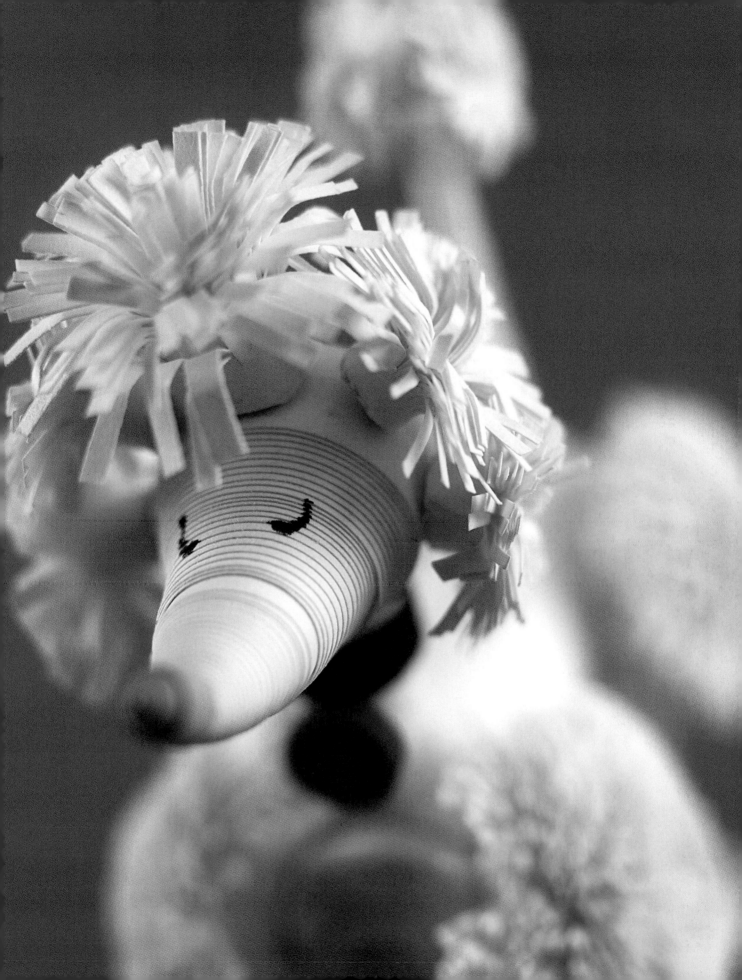

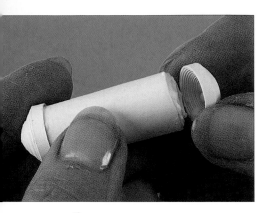

6 To make the body, roll enough 3.5cm wide strips around a pencil to make a ring coil (tube) 15mm (⁵/₈in) in diameter. Use 3mm wide strips to make a cup coil of the same diameter and glue this over the end of the tube. Make another for the other end.

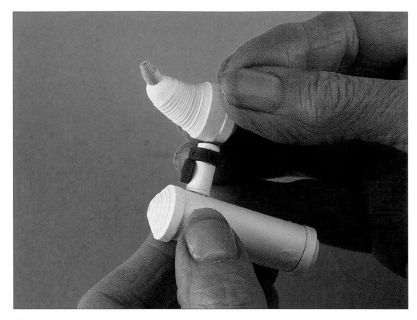

7 Glue the head, neck and body together.

8 To make the tail, use a quarter of a 10mm wide strip to make a tall, thin cone coil, 3.5cm (1³/₈in) long. A cocktail stick makes a good dowel and is also good to ensure that the inside of the tail is well coated with glue. Glue the tail on to the body.

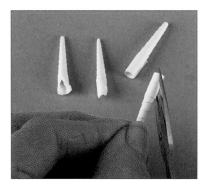

9 Make four legs in the same way and cut the top of each diagonally so that they will better fit the curve of the body.

10 Finely fringe an 8mm wide strip. Divide it into four. Glue one fringed piece to the pointed end of a leg and wrap it around as tightly as possible. Glue down the end. Coat the base of the foot with glue.

11 Spread out the fringes as far as possible. Do this to all four legs and then glue them to the body.

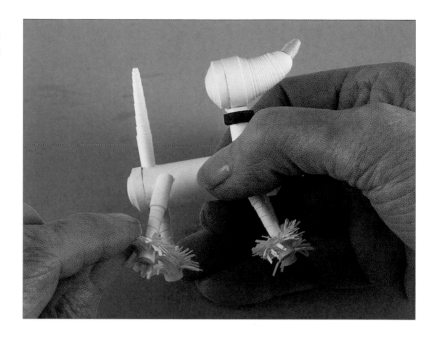

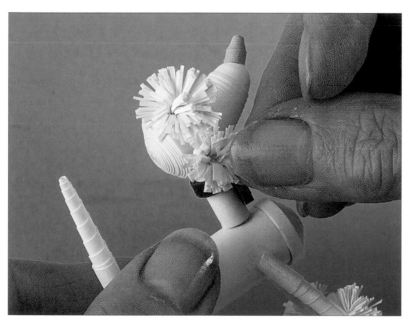

12 To make the ears, fringe a 10mm wide strip and tear it into quarters. Make a pom-pom out of each and glue two to each side of the head.

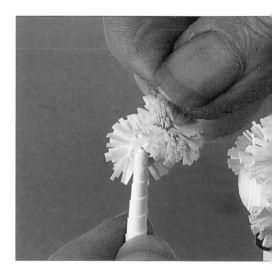

13 Make two more of these pom-poms, exactly the same, and glue them either side of the tail tip.

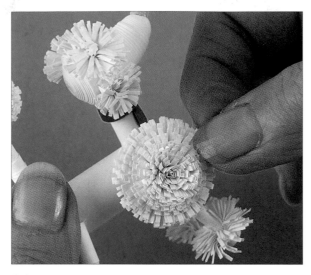

14 Fringe a 10mm wide full-length strip and make it into a pom-pom to be placed at the dog's shoulder. You need one for each side.

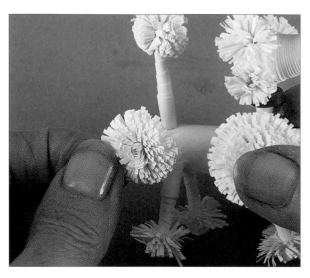

15 Make two smaller pom-poms in the same way for the dog's hips, this time using half-length strips.

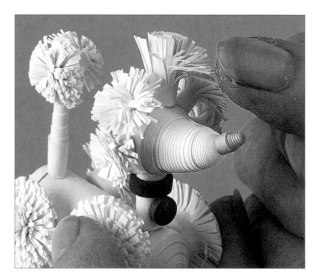

16 Fringe a half-length, 15mm wide strip and roll it up tightly. Glue this to the top of the poodle's head and then spread out the fringes a little.

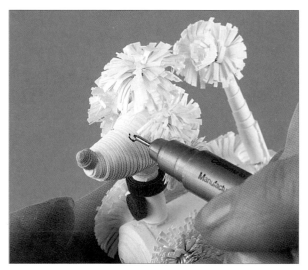

17 Finally, use a very fine fibre-tip pen to draw in the poodle's eyes.

Opposite

The finished Poodle project. The bowl is a solid coil made from 3mm wide strips, 2.5cm (1in) in diameter, with a ring coil placed around its edge. The bone requires four cup coils, each made from a 3mm wide, full-length strip, making two 'balls'; and a tube made around a cocktail stick from a quarter-length, 10mm wide strip.

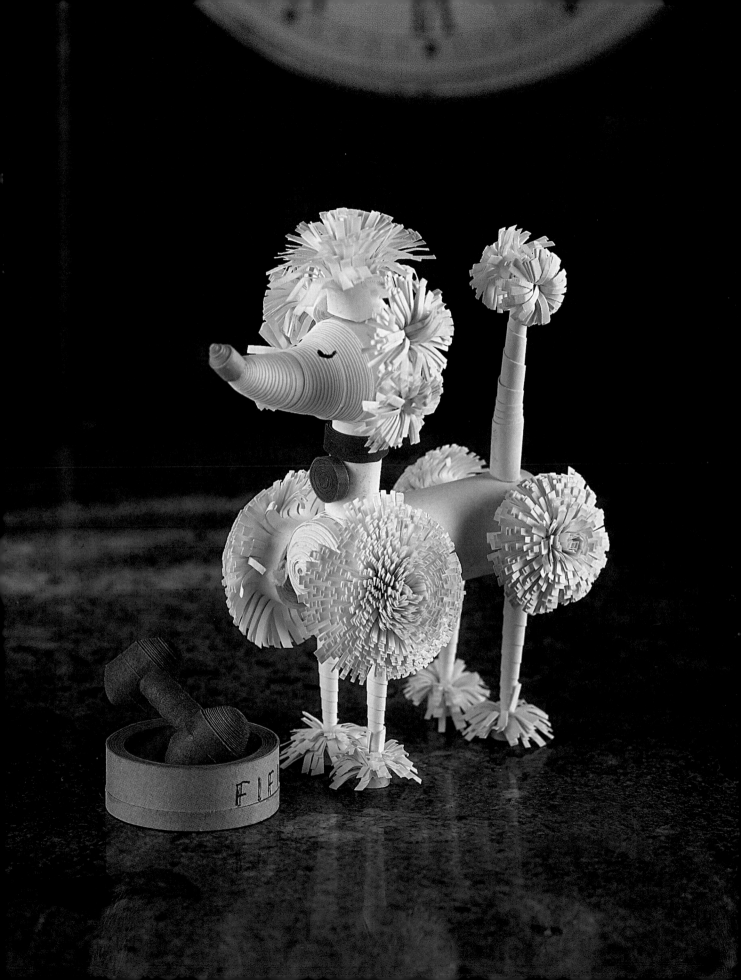

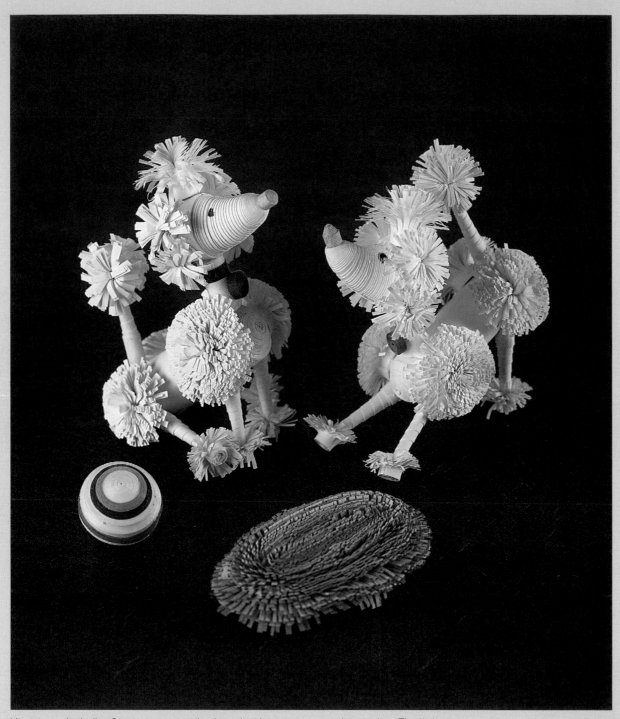

You can make balls of various sizes and colours by gluing two cup coils together. The little rug is made from an oval solid coil using lots of 10mm wide fringed strips; just keep on fringing and adding until the rug reaches the right size or you are exhausted! If you alter the leg positions, you can make poodles that crouch or sit.

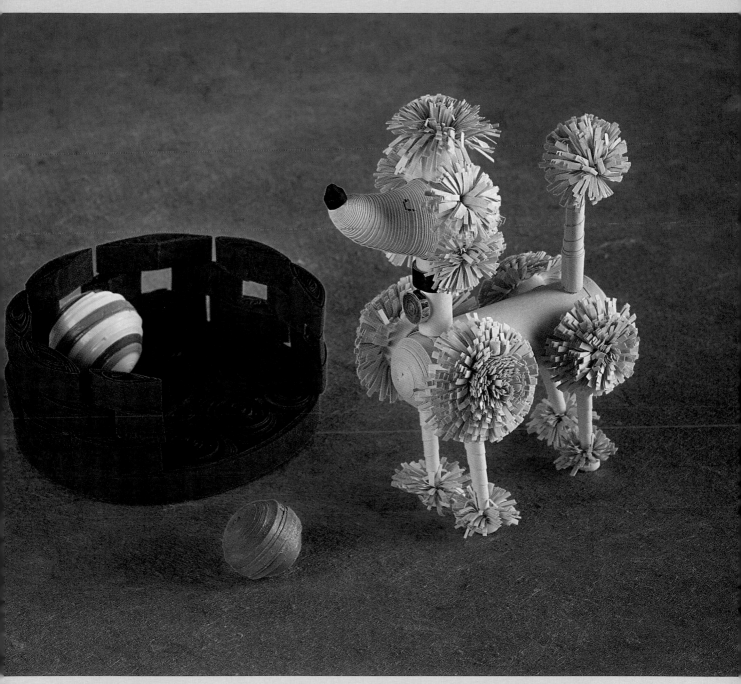

Our pampered pink friend above has a dog basket made from 5mm wide strips. I used six to make a strong ring coil, 6.5cm (2½in) in diameter, and filled it with closed loose coils. The sides of the basket are also made from closed loose coils, mainly using half-length strips and shaped into eye shapes.

Fairy

One of the problems with a free-standing three-dimensional quilling is how to make sure it stands up. I found it especially challenging with this fairy, whose wings tended to make her fall over backwards. I solved the problem by strengthening and enlarging the wings so that she actually stands by balancing on the tip of one wing as well as on her feet. Solving problems such as this is part of the joy of quilling characters – nothing is impossible, it is just a question of trial and error, and a lot of time! I am pleased with this final result, especially with the very modern, holofoil-edged strips which make her glisten with silvery colour.

<div style="float:right;border:1px solid;padding:8px">

You will need

- Six 5mm wide lilac strips
- Three 3mm wide mauve strips
- One 2mm wide mauve strip
- One 2mm, three 3mm and two 5mm peach/ flesh colour strips
- Approximately eight 3mm wide pale yellow strips
- Approximately two 3mm wide canary yellow strips
- Approximately twelve 3mm wide mauve strips with holofoil edging
- Approximately fifteen 3mm wide silver paper strips with holofoil edging
- PVA glue
- Fine scissors
- Extra-fine tweezers

</div>

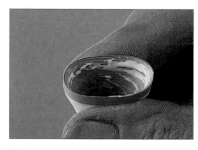

1 To make the bodice, use one 5mm wide lilac strip to make a cone coil. Press it into a slightly oval shape.

2 Flatten the pointed end so that the fairy's waist will not be too narrow. The final height should be 15mm (⁵⁄₈in). Add a quarter-length, 3mm wide mauve strip.

3 For the skirt, use five 5mm wide lilac strips to make a cone coil, not too pointed at the waist (height 3cm; 1¼in). Add a quarter-length mauve strip to the coil. Coat the inside with PVA and before it is dry, flatten the coil a little.

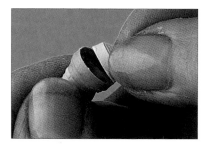

4 To make the shoulders, use one 3mm wide peach/flesh-coloured strip to make a shallow cup coil. Press this into an oval to fit inside the bodice.

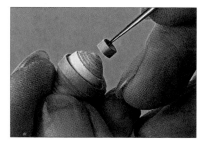

5 To make the neck/choker, use an eighth of a 2mm wide lilac strip to make a tiny ring coil around a cocktail stick. Glue it on to the shoulders.

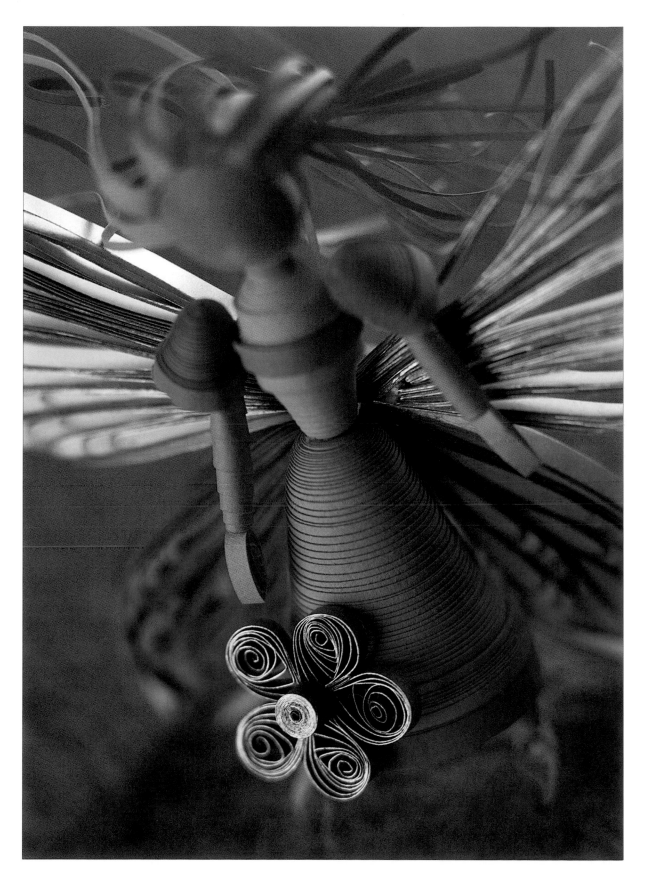

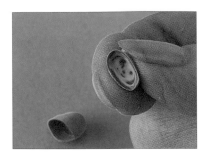

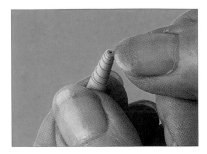

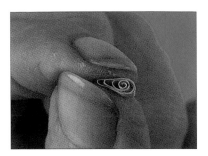

6 To make a sleeve, use a full-length 3mm wide strip to make a fairly deep cup coil. Flatten it a little before the glue coating dries. Make two.

7 To make the arms, use a quarter of a 5mm wide peach/flesh-coloured strip to make a long, thin cone coil. A cocktail stick makes a good dowel. Push the point back so that the wrists are not too narrow. The final length should be about 15mm (⅝in).

8 To make the hands, use an eighth of a 2mm wide strip to make a closed loose coil. Shape it into a teardrop.

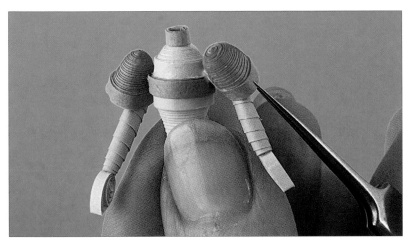

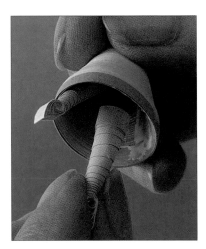

9 Glue the sleeve, arm and hand to each other using tweezers to help you and then glue the whole thing to the bodice. Remember, glue blobs left for a while to go tacky will stick together instantly.

10 Make the legs and feet in the same way as the arms and hands but use a half length for each leg and an eighth of a 3mm wide strip for each foot. Legs should be 3cm (1¼in) in length. Glue them to the inside edges of the skirt.

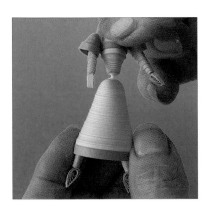

11 Glue the bodice section to the skirt.

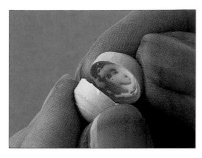

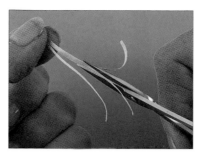

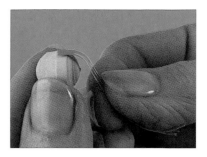

12 To make the head, use two 3mm wide peach/flesh-coloured strips to make a shallow cup coil. Repeat, using pale yellow, and glue the coils together to make a ball.

13 For the hair, cut nine eighth lengths of 3mm strips in pale and canary yellow. Fringe them lengthways as finely as possible, up to 3mm (¹⁄₈in) from the end.

14 Curve into gentle 'S' shapes and glue three to the head, where it meets the face.

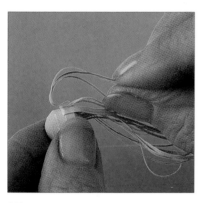

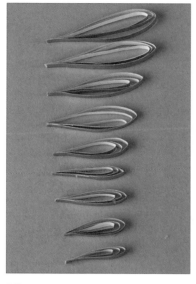

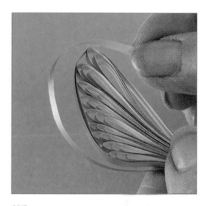

15 Curl one end of six more fringed lengths right over as shown and glue them to the edge of the face.

16 To make the upper wings, use holofoil-edged silver-coated 3mm wide strips to make nine wheatear coils which have only three loops at their rounded ends. The smallest should be approximately 2.5cm (1in) long. Make them very slightly bigger each time so that the longest is 5.5cm (2¹⁄₄in) long.

17 Glue these to each other and put a tiny dot of glue on the rounded end of each. Glue on another strip at the wing base and wrap it around the wheatears to hold them all together. Carry on wrapping round to use up as much strip as possible but finish it at the base of the wing. Glue down the end.

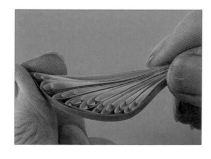

18 Give the wing a pinch at its top to make a good wing shape.

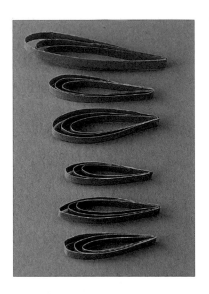

19 To make the lower wing, use 3mm wide, holofoil-edged mauve strips to make six wheatear coils with only three loops at the rounded ends. One wheatear should be 4.5cm (1¾in) long. Two should be 4cm (1⅝in) long and three should be 3cm (1¼in) long.

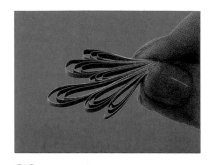

20 Glue them to each other in this order: small, medium, small, long, medium, small.

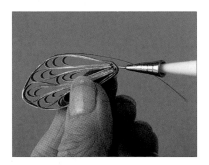

21 Put a tiny dot of glue on the rounded end of each wheatear. Add another strip to the base and wrap it snugly around all the wheatears. Use as much of the strip as possible. Cut off any excess.

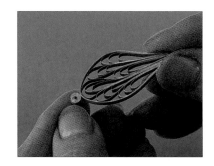

22 Make a tiny solid coil from a quarter-length, 3mm wide mauve, holofoil-edged strip and glue it to the tip of the wing.

23 Glue a silver-coated, holofoil-edged strip to the base of the wing and loop it around to enclose the tiny solid coil within the wing. Pinch into a pointed shape.

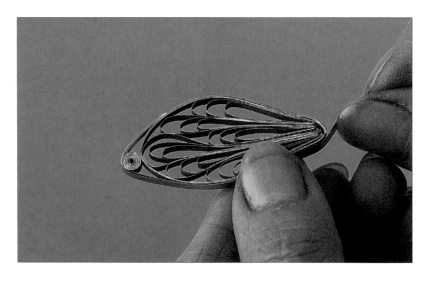

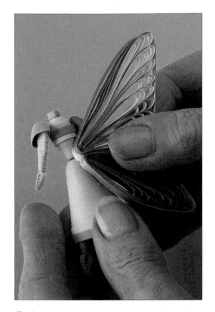

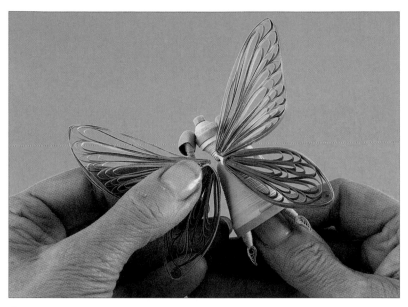

24 Glue the upper wing to the lower wing and then to the back of your fairy.

25 Make a second set of upper and lower wings and glue them to the other side of the fairy's back.

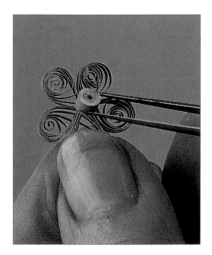

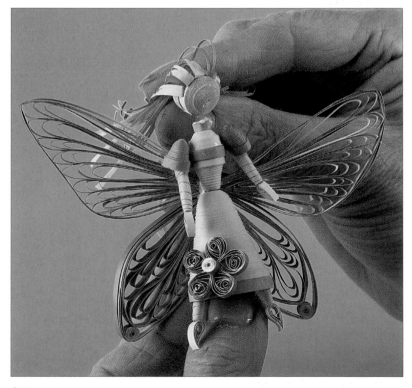

26 To make the decorative flower for her dress, use five 2mm wide, eighth-length strips for petals. Make each into a closed loose coil teardrop shape. The flower centre is a tiny solid coil made from a sixteenth of a 2mm wide strip.

27 Finally, glue on the fairy's head.

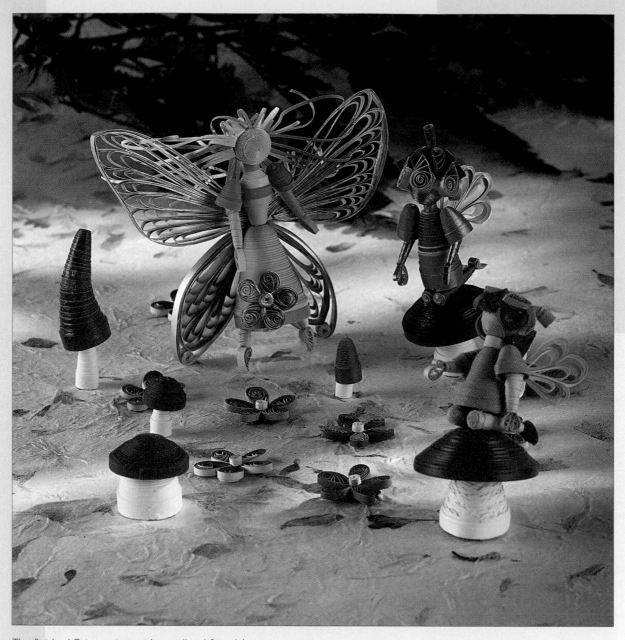

The finished Fairy project with woodland friends!

The elves: the head, neck, sleeves, face, arms, feet and hands are as for the fairy. The legs are as for the fairy but shorter. The knees are a shallow cup coil made from a quarter of a 2mm wide strip. The body is a 2.5cm (1in) tall cone coil made from three 5mm wide strips. The thumb is a closed loose coil made from a sixteenth of 2mm wide strip. The wings are made from three wheatears (as for the fairy but smaller), glued to each other with no enclosing loop.

The flower hat has six petals: closed loose coil teardrops made from quarter-length, 2mm wide strips. The six sepals are closed loose coil long, thin teardrops made from eighth-length, 2mm wide strips. The stalk is a cone coil made from an eighth of a 5mm wide strip.

The toadstool cap is a cup coil made from 3mm wide strips to a diameter of 3.5cm (1³/₈in). The toadstool stalk is a cone coil made from 5mm wide strips to a diameter of 2cm (³/₄in) and then pushed to a height of about 2cm (³/₄in). Toadstools can be made in a huge variety of shapes by altering these lengths.

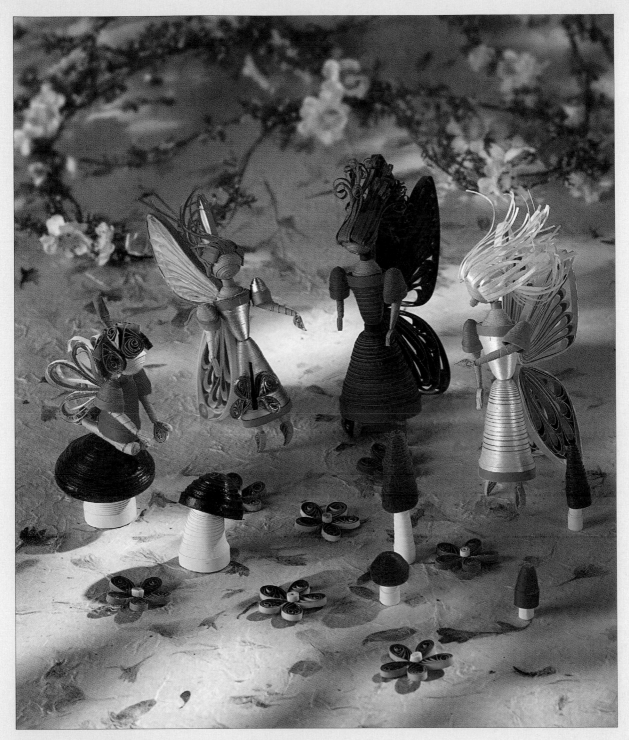

Fairies and an elf in different colours gather in the woods.

Angel

Here, the challenge is to make a large figure. The cone coil that makes her tunic is 10cm (4in) tall and has to be carefully worked using the potter's method (see page 9) so that it very gradually grows to the required size. The angel's wings are made using a technique which is not strictly quilling but derived from Swiss straw-work. Instead of a coil, you produce a 'spreuer' (rhymes with soya) which is made on a comb or, in this case, two onion holders. If you choose to make the wings from the very shiny mirror paper strips, you will need to use a stronger PVA glue.

You will need

- White strips: approximately forty 15mm wide and twelve 10mm wide
- Peach/flesh strips: approximately fifteen 3mm wide and two 5mm wide
- Strips in various yellows: approximately fifteen 3mm wide; six 5mm wide and four 2mm wide
- Two 3mm wide white gold-edged strips
- Four 2 x 3cm (¾ x 1¼in) peach/flesh paper rectangles
- Approximately thirty-five 3mm wide bright yellow gold-edged strips
- Approximately twenty 3mm wide mirror strips, gold surface
- Two onion holders, masking tape and a pencil
- Very fine black fibre-tip pen
- Tweezers
- Cocktail stick
- PVA and extra-strong PVA glue
- 15mm (1⅛in) dowel

1 To make the angel's body, use 15mm wide strips to make a solid coil, 5cm (2in) in diameter. Work this into a cone coil, 10cm (4in) tall and coat it with PVA glue.

2 For the collar, roll a quarter-length, 10mm wide strip around a pencil to make a ring coil. Cut it diagonally as shown. Glue it to the body.

3 To make the head, use 3mm wide peach/flesh-coloured strips to make a cup coil, 3cm (1¼in) in diameter. Repeat, using any yellow strips randomly. Glue the two cup coils together to make a ball.

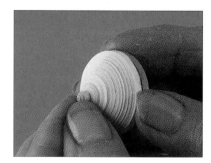

4 For the nose, use an eighth of a 1.5mm or 2mm wide strip to make a tiny cup coil. Coat the inside with glue and position it on the face.

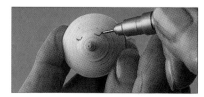

5 Draw in the eyes using a very fine black pen.

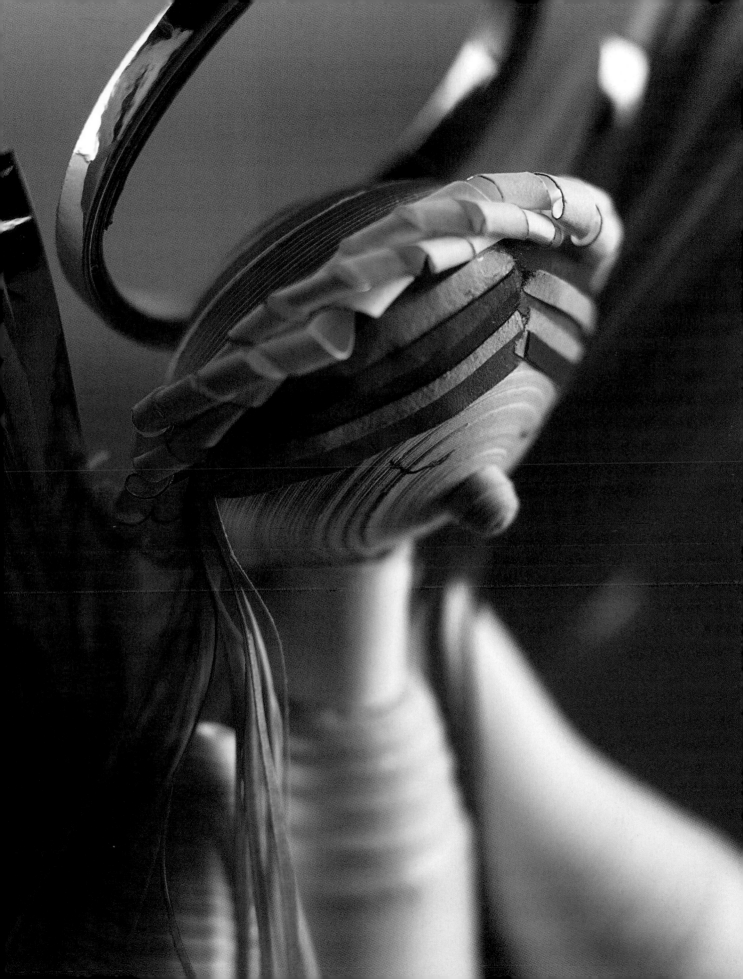

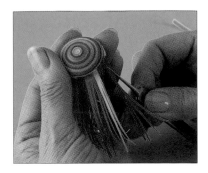

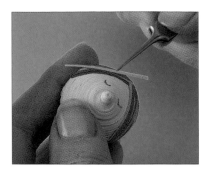

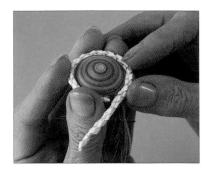

6 To make the hair, cut six 5mm wide yellow strips into quarters and fringe each lengthways as finely as possible, up to 3mm (⅛in) from the end. Glue these along the back of the hair/face join line.

7 Cut some 2mm wide strips in shades of yellow into 3cm (1¼in) long lengths. Glue to the centre of the forehead and back towards the ear position. Use yellows randomly and overlap occasional ones.

8 To make the wreath, use three half-length white 3mm wide gold-edged strips to make tendrils. Twist them together and glue the wreath around the hair/face join. Cut off any excess.

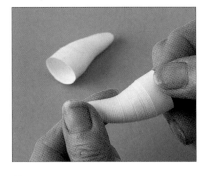

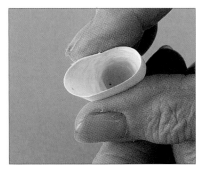

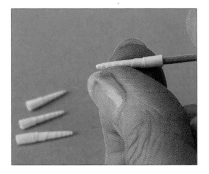

9 For the sleeves, use 10mm wide strips to make a solid coil, 2cm (¾in) in diameter. Shape into a curved cone coil, approximately 5cm tall.

10 Coat the inside of each coil with glue and before it dries, press it into an oval shape.

11 To make the fingers, use 5mm wide peach/flesh-coloured strips. Each finger is a tiny cone coil made from an eighth of a strip and pushed on to a cocktail stick.

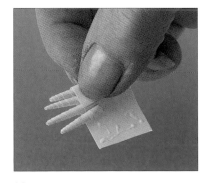

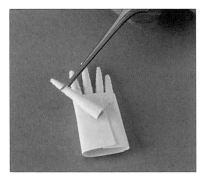

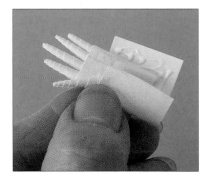

12 Glue four fingers together. Use a 2 x 3cm (¾ x 1¼in) strip to wrap around the base of the fingers to make a hand.

13 Use tweezers to place the thumb coil on the hand a little lower than the fingers.

14 Wrap another 2 x 3cm (¾ x 1¼in) strip around the hand to enclose the thumb. Make a second hand.

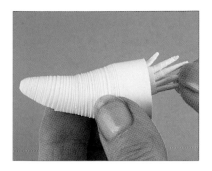

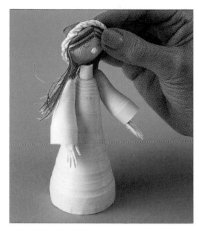

15 Glue each hand inside a sleeve with the thumb uppermost.

16 Glue on the sleeves and the head. Remember that two blobs of glue, if left to go tacky, will stick together instantly.

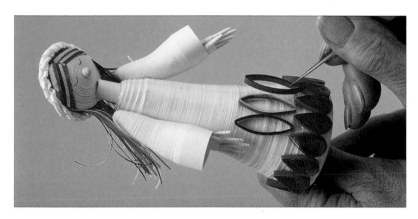

17 To make the decoration on the tunic, use 3mm wide bright yellow, gold-edged strips. Along the hem are closed loose coils shaped into teardrops, each one made from a full-length strip. Above them are ring coils (also one strip) made around a 15mm (1¹⁄₈in) diameter dowel and pressed into eye shapes. Glue the decorations on as shown.

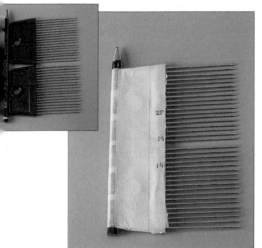

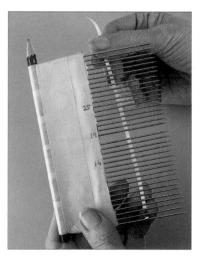

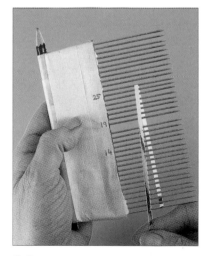

18 Fix two onion holders together, side-by-side, using masking tape and a pencil to hold them rigid. Mark prongs 14, 19 and 25.

19 To make the angel's wings, use 3mm wide mirror strips to create large spreuers. Make a tiny loop at the end of a strip and glue it firmly. Slot this loop on to the bottom prong of the onion holders and take it up the back.

20 Loop the strip over prong 26 and bring it down to the base again.

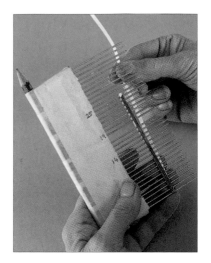

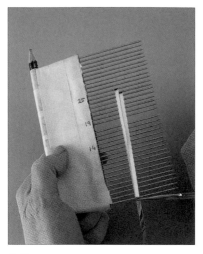

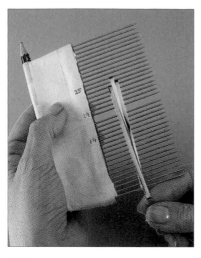

21 Put a tiny dot of glue at the base and then bring the strip up behind the onion holder again.

22 Go over prong 25 on the right, then back down to the base and glue the strip in place. The strip is running out, so trim the end and stick on another strip. This is how to add more strips whenever you run out.

23 Take the new strip up and over prong 24 on the left, then down to the base. Glue it.

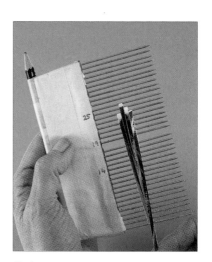

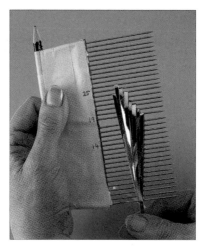

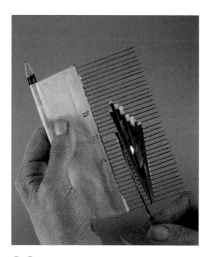

24 Go over prong 24 on the right, down to the base and glue.

25 In the same way, go over prongs 23, 22, 21, 20 and 19 on the right side only. Always glue at the base.

26 Take the strip over prong 19 on the left, down to the base and glue.

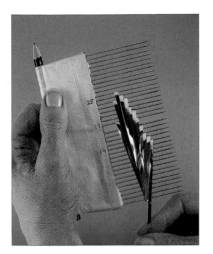

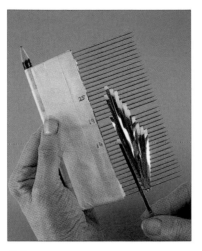

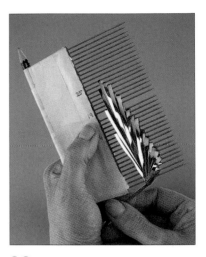

27 Now go over prongs 18, 17, 16, 15 and 14 on the right only. Glue at the base.

28 Take the strip over prong 14 on the left, down to the base and glue.

29 Now go over prongs 13, 12, 11, 10, 9, 8, 7, 6, 5, 4, 3 and 2 on the right only.

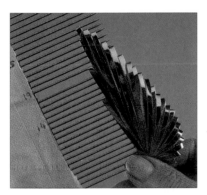

30 When the glue is dry, slide the spreuer off the onion holders.

31 Repeat to make a second wing and glue them both to the angel's back, using extra strong PVA glue. Remember that two blobs of glue, left to go tacky, will adhere instantly.

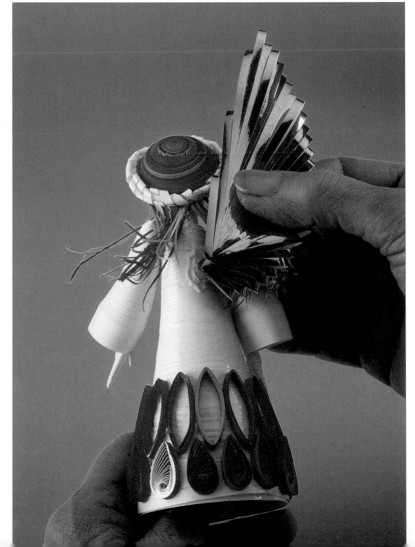

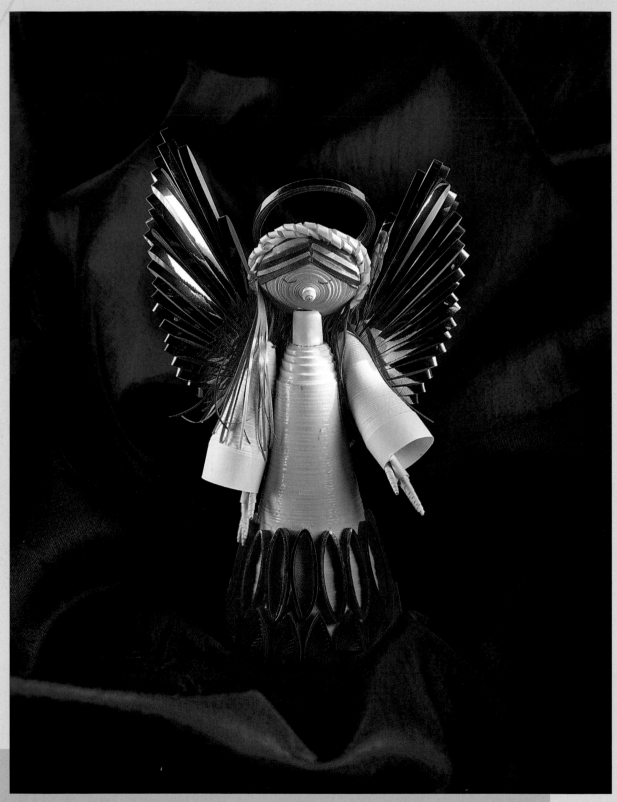

The finished Angel project. Having done a little 'angel research', I find that haloes are optional! If you want yours to have one, use a 3mm wide gold mirror strip to make a ring coil about 3cm (1¼in) in diameter and glue it to the back of the angel's head.

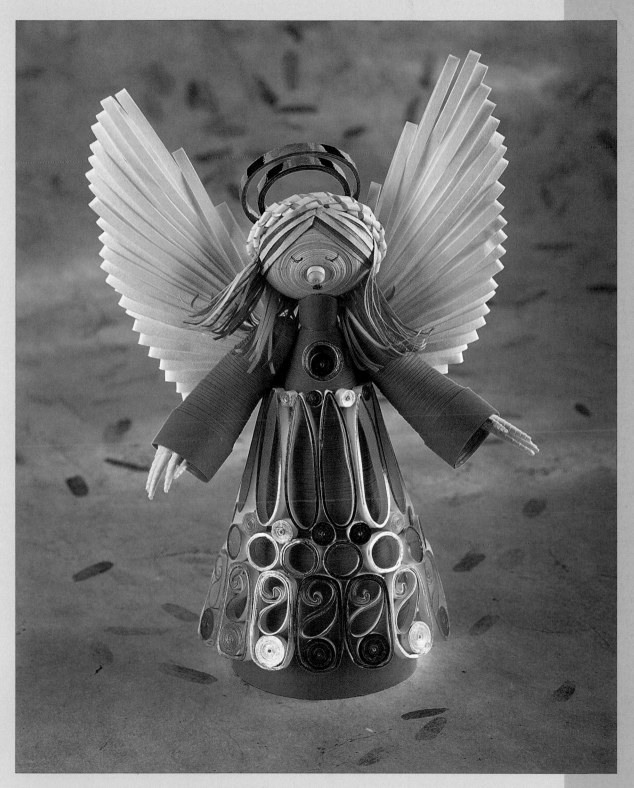

This angel's lacy overskirt was made on a former, slightly bigger than the angel's tunic. I made the former from soft modelling clay covered with plastic food wrap. The closed loose coils, ring coils etc. were glued to each other and held in place with pins until the glue dried. When complete, the overskirt could be slipped off the former and attached to the tunic.

Index